GREENWICH
HISTORY TOUR

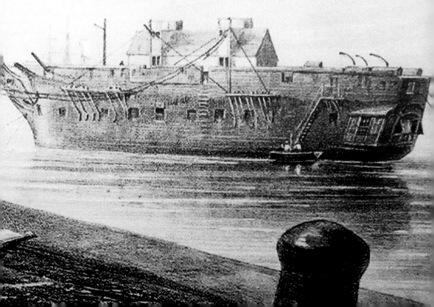

This book is dedicated to Alex, Toby and Elizabeth.
The images of the past can have reflections on your future.

First published 2019

Amberley Publishing
The Hill, Stroud,
Gloucestershire, GL5 4EP
www.amberley-books.com

Copyright © David C. Ramzan, 2019
Map contains Ordnance Survey data
© Crown copyright and database
right [2019]

The right of David C. Ramzan to be
identified as the Author of this work
has been asserted in accordance with
the Copyrights, Designs and Patents
Act 1988.

ISBN 978 1 4456 9290 6 (print)
ISBN 978 1 4456 9291 3 (ebook)

British Library Cataloguing in
Publication Data.
A catalogue record for this book is
available from the British Library.

Origination by Amberley Publishing.
Printed in Great Britain.

INTRODUCTION

Greenwich was a small village situated on the south bank of the River Thames when the first settlers, the Anglo-Saxons, gave the settlement the name 'Grenewic' – green village, or village on the green. There is evidence of pre-Roman activity in the area and remains of a Roman temple have been found within Greenwich Park. To the west of the temple are a series of mounds, thought to be Bronze Age barrows, used as burial grounds by those first settlers who put Greenwich on the historical map.

The Danish invaders made Greenwich their base while carrying out attacks upon Kent and Canterbury. Alfege, the Archbishop of Canterbury, was taken hostage during one of these raids and after months in captivity was stoned to death by his captors. The archbishop's martyrdom assured him saintly status and a church was built on the site where he died.

After the Norman invasion, William the Conqueror's half-brother Odo of Bayeux held lands at Greenwich. The manor was seized by the Crown after Bishop Odo was found guilty of fraud. The manor gained royal patronage after Edward III had a chapel and hunting lodge built at Greenwich. Henry IV signed his will at the manor which was inherited by the king's half-brother Thomas Beaufort, Duke of Exeter, who resided at a riverside property, Bella Court. On his death the property passed to Humphrey, Duke of Gloucester. The building was enlarged and given the title Bella Court Palace.

Henry VI inherited the palace and manor after the death of his uncle Humphrey and Bella Court Palace was renamed Placentia. Extensive rebuilding work took place during the Tudor period under the instructions of Henry VII. The medieval buildings were then replaced by the magnificent Greenwich Palace.

Henry VIII was born at the palace, as were his daughters, Mary and Elizabeth. The king spent many years of his reign at Greenwich overseeing the development of his naval dockyards at Woolwich and Deptford. After the turn of the sixteenth century the whole area would go through a dramatic transformation through the successful development of the shipbuilding industries. As working opportunities increased, so did the population, which resulted in a change to the whole industrial and social development of Greenwich.

By the time of the English Civil War the monarchy had fallen out of favour with the people and the Tudor palace had fallen into disrepair. Plans to build a new palace were commissioned by Charles II after the monarch's restoration to the throne. However, this new palace was never completed and when William and Mary succeeded the throne the queen instructed Sir Christopher Wren to complete the building as a hospital for sailors on the site of the old palace.

During the sixteenth and seventeenth centuries the dockyards at Woolwich and Deptford had grown and expanded, and new industries were required to complement the shipbuilding, including ironworking, milling, munitions manufacturing, barge and boat building.

By the end of the nineteenth century industry and housing had grown beyond compare. To the east of Greenwich row upon row

of Victorian and Edwardian terraced houses had been built to accommodate the working families employed in the trades and industries on Greenwich Marsh and along the river from Woolwich to Deptford. The properties to the west of Greenwich consisted of elegant Regency houses and shops with a prosperous market square at the centre. Dividing East and West Greenwich were the magnificent buildings of the Royal Hospital and the Royal Hospital School, with the wide green expanse of the Royal Park situated to the south.

Greenwich was not only divided by social and industrial necessity, but also by the Meridian Line passing through the town's centre running north and south from the Royal Observatory in Greenwich Park. Positioned at 0 degrees longitude, the line divided the globe's western and eastern hemispheres with Greenwich at the centre.

After almost 2,000 years of living history, Greenwich was awarded World Heritage status and made a Royal Borough, an honour granted by Elizabeth II in recognition of the monarchy's long associations with the maritime town.

Being born in Greenwich, I spent all of my childhood years playing with friends in the streets, the park and along the riverfront of a Greenwich which has seen continued change and redevelopment over time. I hope that within this history tour of the Royal Borough of Greenwich I have been able to reflect upon its ever-changing image and guide the reader around its most famous and fascinating landmarks.

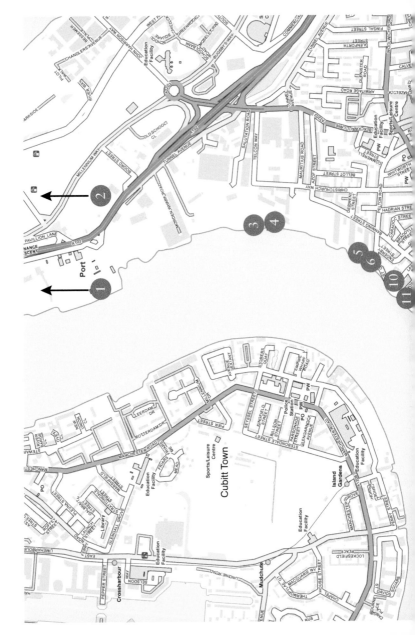

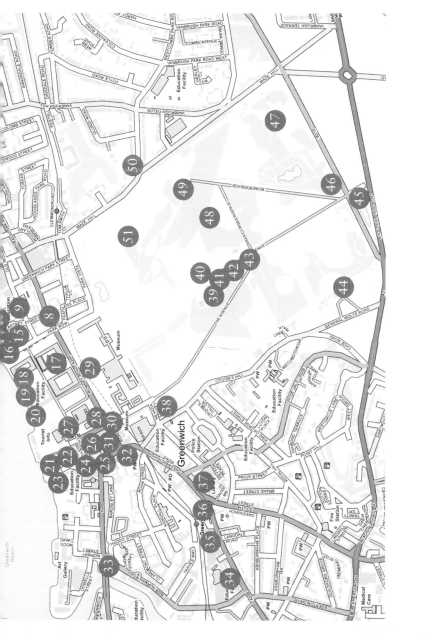

1. BLACKWALL POINT

This image shows Blackwall Point in the late eighteenth century, an East Indiaman moored opposite Greenwich Marsh gibbet, where pirates' corpses were hung in chains. The last reported exhibiting of corpses on a cross-headed gibbet took place in 1816, their crime being the theft of £13,000 in dollars transferred to a merchant ship bound for India.

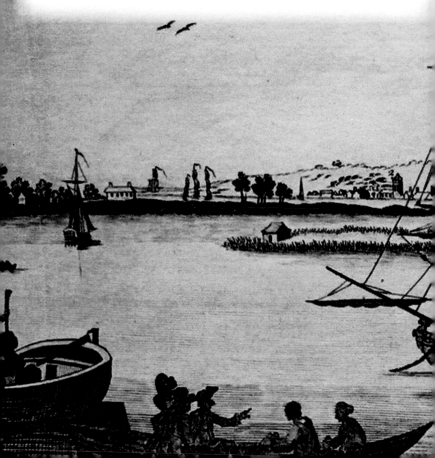

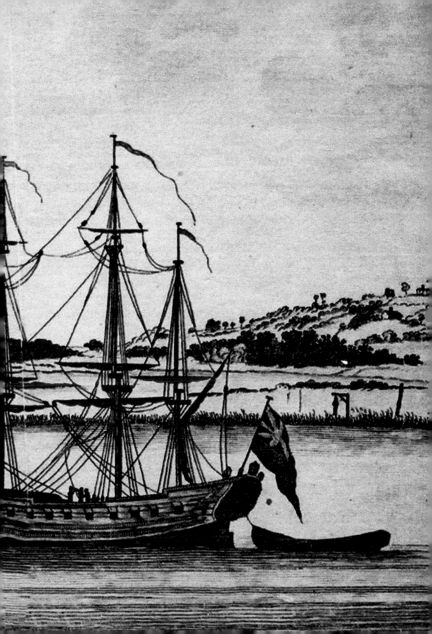

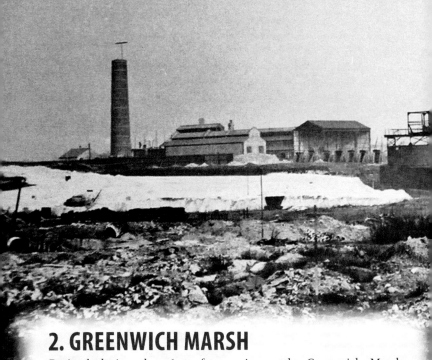

2. GREENWICH MARSH

Drained during the 1600s for grazing cattle, Greenwich Marsh became heavily industrialised between the eighteenth and nineteenth centuries. By the end of the twentieth century the whole area began a programme of regeneration, as the old industries – ship and boat building, refining of chemicals, production of gas, glucose, cements and building aggregates – all closed. As part of the 2000 millennium celebrations, a great dome was erected, the yellow support towers reaching up to the sky, replacing the tall chimneys that were once part of the industrial landscape.

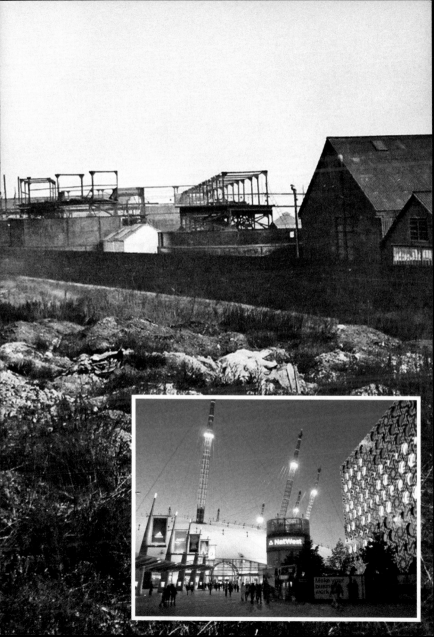

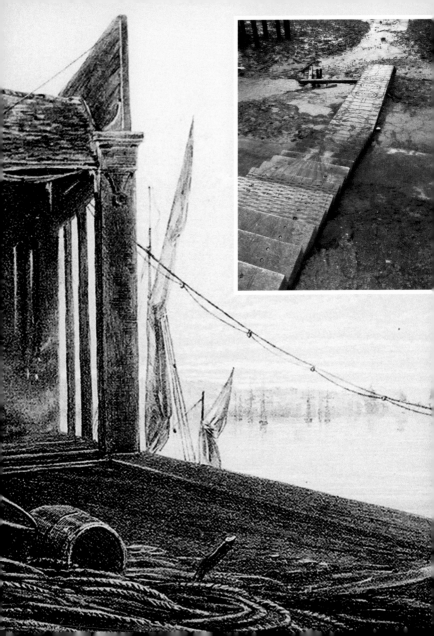

3. *MAN OF WAR*

This image shows the *Amethyst* loading subsea telegraph cable off Enderby Wharf *c.* 1865. The site was acquired by the Enderby family to produce ships' rope and canvas. Next to the wharf are Enderby's ferry steps, where ferrymen rowed crews to and from the cable ships. Sculptor Richard Lawrence was commissioned to carve a new set of ferry steps depicting the heritage of Greenwich Marsh and the Enderby site, to cover the original steps built over a medieval sluice.

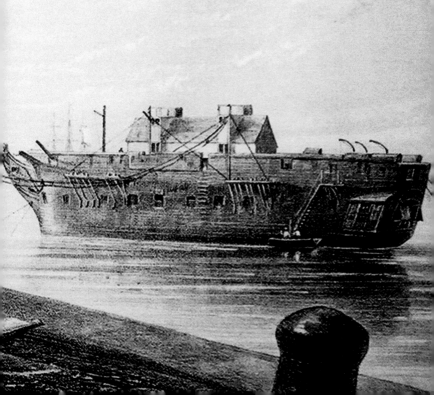

4. GLASS ELLIOT

A main employer in Greenwich during the mid-1800s was Glass Elliot & Co., telegraph cable manufacturers. The site was originally occupied by the Enderbys, a family of whaling entrepreneurs. The transatlantic submarine telegraph cable laid by Brunel's Great Eastern in 1866 was manufactured on the site now under the ownership of Alcatel, a company currently making components for the communication industry. The only original riverside building that remains is the 1830s listed Enderby family house, under conversion into a bar and restaurant.

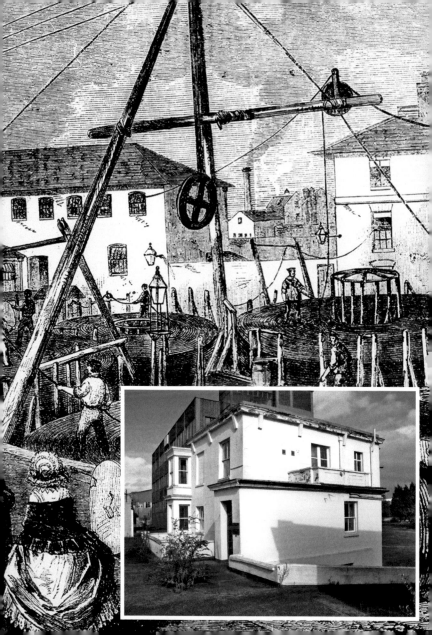

5. LOVELL'S WHARF

Lovell's Wharf, previously known as Greenwich Wharf, was built to deal in coal shipments, until Shaw Lovell & Co. took over the lease in the 1920s to handle shipments of non-ferrous metals. Two large cranes, Scotch Derricks, of historical and industrial interest, were removed along with the iconic brick wall after Lovell's moved out in the 1980s. While the site was in the process of residential redevelopment, archaeologists uncovered remains of a twelfth-century tidal mill, preserved in peat deposits, the oldest discovered in London.

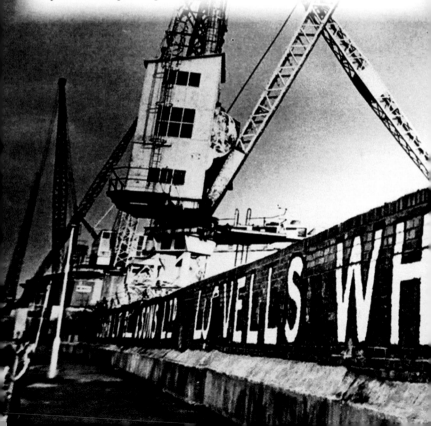

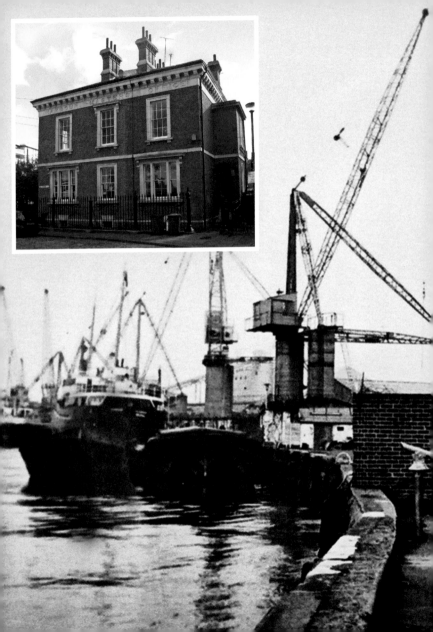

6. BALLAST QUAY

This image shows Ballast Quay, where ships had been taking on ballast since the seventeenth century, after offloading their cargo. To the east of the quay is the Harbour Master's Office, built in 1855 by local architect George Smith, replacing an office located near the Yacht Tavern. The Greenwich Harbour Master controlled movement of colliers on the Thames bringing in shipments of coal from the north-east for use as fuel for riverside power stations and industries. The office closed in 1890 and was converted into a private residence.

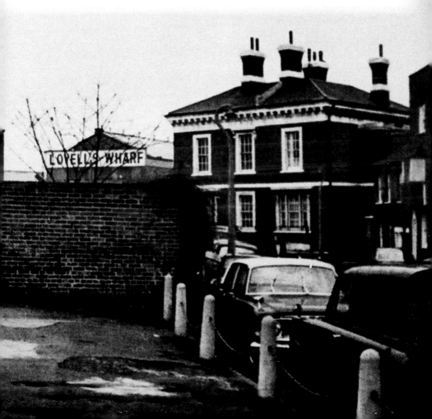

7. EAST GREENWICH TRAM

This image shows East Greenwich tram number 36 running on the last of the city's tram routes in 1952. To the left of Trafalgar Road is the Victorian-built Christ Church, opposite a row of local shops and two public houses, the Crown and the British Queen. Throughout the 1960s and '70s many shops were replaced by fast-food outlets and supermarkets. As East Greenwich became a more fashionable place to live, independent shops selling specialist goods made a comeback.

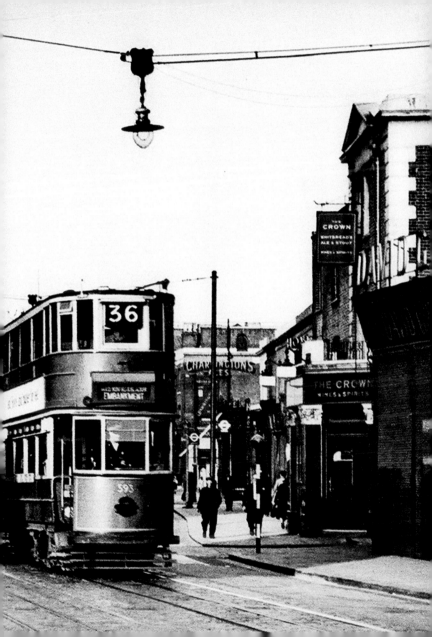

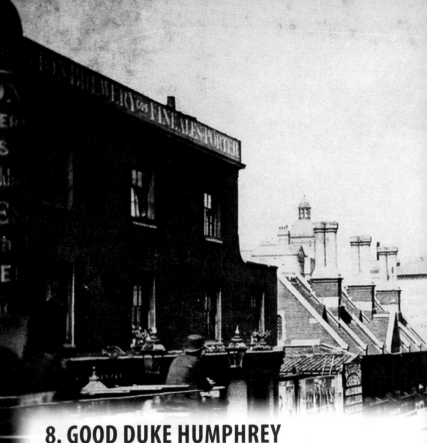

8. GOOD DUKE HUMPHREY

Good Duke Humphrey, a large nineteenth-century coffee house situated at the junction of Trafalgar Road and Park Row, was a popular place of entertainment. Named after the younger brother of Henry V, Humphrey, Duke of Gloucester, the nobleman held the manor of Greenwich during the mid-fifteenth century. The building was demolished in the early 1900s, the public house and almshouses opposite destroyed during bombing raids in the Second World War, replaced by new residential properties, a car park and petrol station.

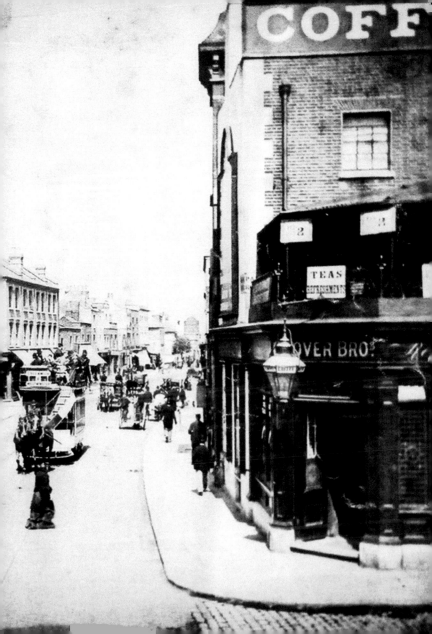

9. GREENWICH POWER STATION

When electrified trams replaced horse-drawn trams, Greenwich Power Station was built (in two phases, between 1902 and 1910) to provide power for London's tram routes. As electrified trams were phased out after the Second World War, the power station became the backup to run London's Underground system. The power station's truncated octagonal chimneys once measured almost 250 feet high; the chimneys built during the second stage were reduced to 180 feet after objections by the Royal Observatory. There are now plans to install six new gas turbines providing low carbon energy to power London's Tube and supply heat and hot water to local schools and homes.

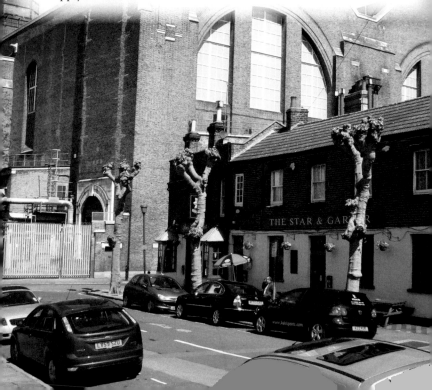

10. UNION WHARF

Merging into Ballast Quay, Union Wharf is well known for its famous riverside tavern, the Cutty Sark, the building dating to the late 1700s. Once frequented by merchant sailors, Thames lightermen and watermen, the tavern acquired the name Cutty Sark in 1954, after the famous clipper's arrival at Greenwich. Originally named the Green Man, after being rebuilt this historic public house was named the Union Tavern after its location, Union Wharf.

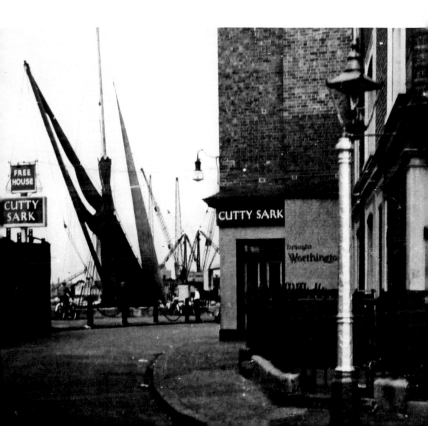

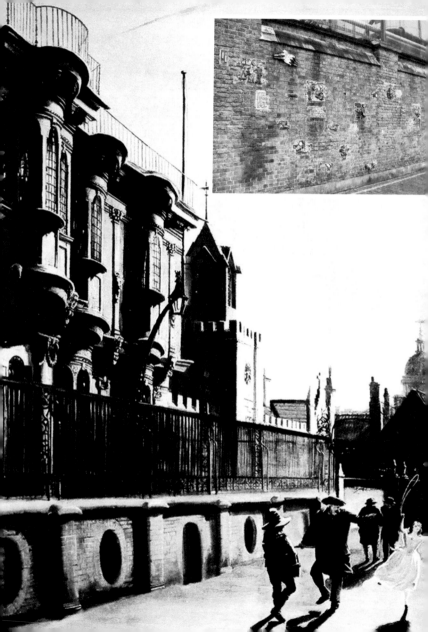

11. CROWLEY HOUSE

In 1647 London merchant Sir Andrew Cogan began the construction of a mansion that was completed after the Civil War by Parliamentarian Gregory Clement. Named Crowley House when purchased by Sir Ambrose Crowley from Newcastle in 1704, an iron merchant who made his fortune producing navy anchors and shackles and chains for the slave trade, the impressive property was demolished in 1854. Greenwich Power Station was later built on the site. A three-dimensional story on the power station wall, created by Amanda Hinge, tells of a boy's adventure by the river.

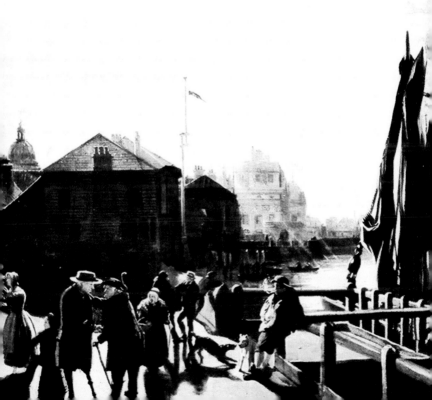

12. TRINITY ALMSHOUSES

Founded in 1613 by the Earl of Northampton, Trinity Almshouses provided accommodation for retired gentlemen of Greenwich. The hospital, the oldest building in the centre of Greenwich, is run as a charity by the Mercers' company who provide care for elderly residents. The attractive and historic hospital and almshouses are overshadowed by Greenwich Power Station.

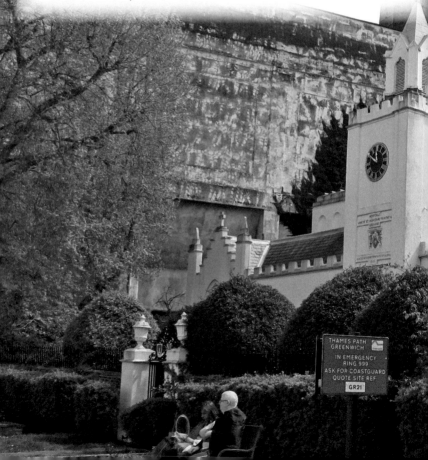

THAMES PATH
GREENWICH

IN EMERGENCY
RING 999
ASK FOR COASTGUARD
QUOTE SITE REF.

GR21

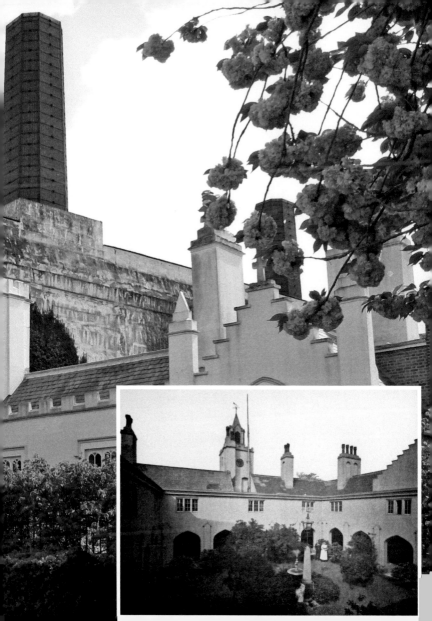

13. CROWN & SCEPTRE

This image shows the Crown & Sceptre public house at Highbridge Wharf at the turn of the nineteenth century. The wharf was named after a fifteenth-century bridge once used to move goods from ship to shore. In the sixteenth century it was forbidden for Venetian galleys to sail beyond Highbridge for fear of piracy. All the working riverfront buildings at Highbridge were gradually replaced by small commercial and residential properties. The weatherboarded public house was once the headquarters of Curlew Rowing Club, the oldest rowing club on the tideway.

14. CORBETT'S

Rowboats of all types were hired at Corbett's boatbuilders pontoon to the rear of Crane Street, used for storing their own boats and those of local rowing clubs. J. Corbett & Sons had been building boats at Wood Wharf since the mid-1800s. The house behind Corbett's pontoon still exists, next to the Trafalgar Rowing Club. Further to the right is the Yacht Tavern where you can watch boats and rowers from one of the bars overlooking the river.

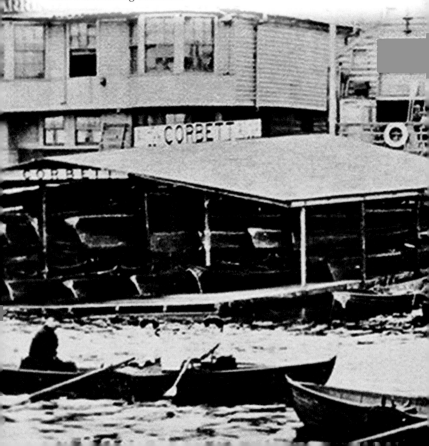

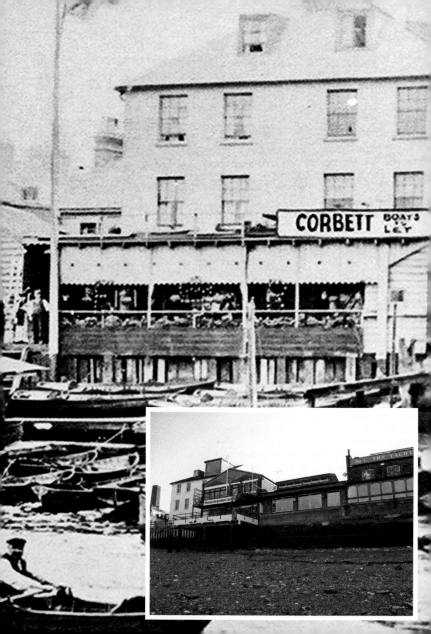

15. CRANE STREET

These historic weatherboarded riverside buildings of the late 1800s were situated on Crane Street leading from Highbridge Wharf. The street name has associations with a crane which stood on the site in 1730, used for loading and offloading vessels. Many of these historic riverside buildings were demolished and replaced by blocks of residential properties.

16. TRAFALGAR TAVERN

The Trafalgar Tavern, built in 1837 to replace the older George Inn, was a rival to the Ship Tavern at Greenwich Pier, both famed for serving whitebait dinners to MPs. A favourite haunt of social critic Charles Dickens, the author wrote of the tavern in his novel *Our Mutual Friend*. Outside the main entrance stands a bronze statue of Admiral Lord Nelson.

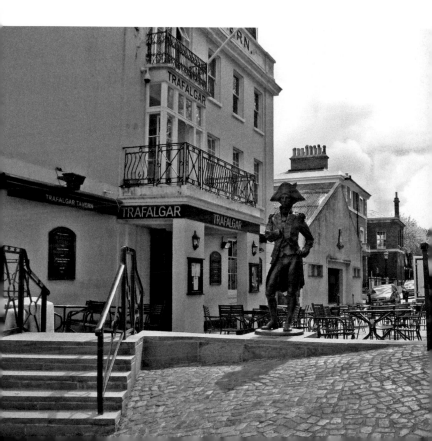

17. ROYAL NAVAL COLLEGE

Commissioned by Charles II in 1660, the Old Royal Hospital was acquired by the Royal Navy in 1873. The Royal Naval College incorporated the Naval Architectural College of Portsmouth and the Marine Engineering College of South Kensington. During the Second World War, over 27,000 officers and 8,000 WRNS were trained at Greenwich. When the college relocated to Suffolk in 1998, a nuclear reactor – Jason, one of very few operating in a highly populated area – was removed from King William's Quarter, along with over 250 tons of nuclear waste.

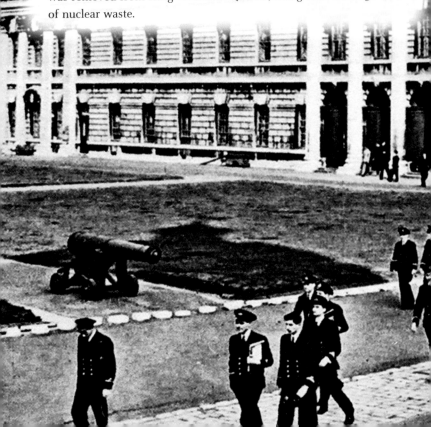

18. GREENWICH PALACE

Originally a manor house held by William the Conqueror's half-brother Odo, the building was later extended and became known as Bella Court Palace and then the Palace of Placentia. Under instruction of Henry VII, the medieval buildings were demolished and replaced by the magnificent Greenwich Palace. Occupied by Parliamentarians during the English Civil War, the palace fell into disrepair and was demolished after the Restoration of the Monarchy, the site used for a proposed new palace. *Inset*: Stone laid between the east and west wings of the Old Royal Hospital commemorating Greenwich Palace.

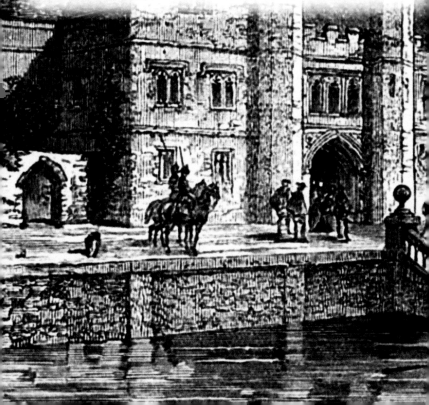

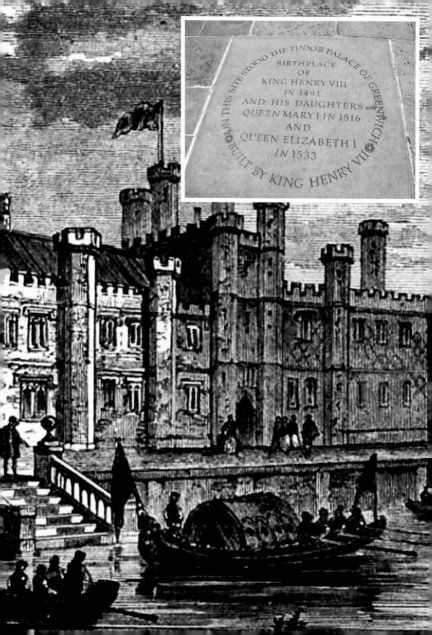

ON THIS SITE STOOD THE TUDOR PALACE OF GREENWICH

BIRTHPLACE
OF
KING HENRY VIII
IN 1491
AND HIS DAUGHTERS
QUEEN MARY I IN 1516
AND
QUEEN ELIZABETH I
IN 1533

BUILT BY KING HENRY VII

19. GREENWICH BEACH

A day out at Greenwich Beach in the 1930s. The strip of sand and shingle was a popular place for families to visit. Victorians came to the beach to paddle and play in the river, even though the Thames was heavily polluted from industrial waste at the time. The beach is reached by the Queen's Steps in front of the Old Royal Hospital, where on sunny summer days people can relax next to a much cleaner River Thames.

20. GREENWICH HOSPITAL

For over 400 hundred years the Thames flowed back and forth past the Greenwich Hospital for Royal Naval Pensioners, an architectural masterpiece designed as a palace in 1664 by architect John Webb for Charles II. Remodelled by Sir Christopher Wren, Hawksmoor and Vanbrugh (Wren's contemporaries) under instruction from Mary II for use as hospital (charitable institution), the project took over fifty years to complete.

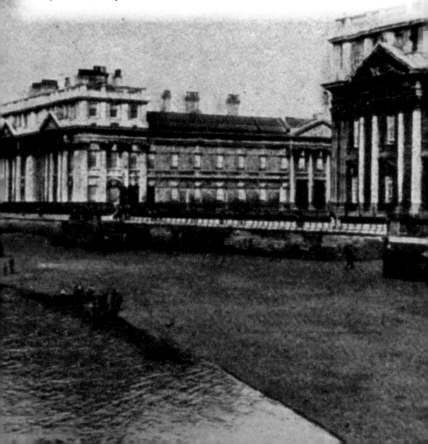

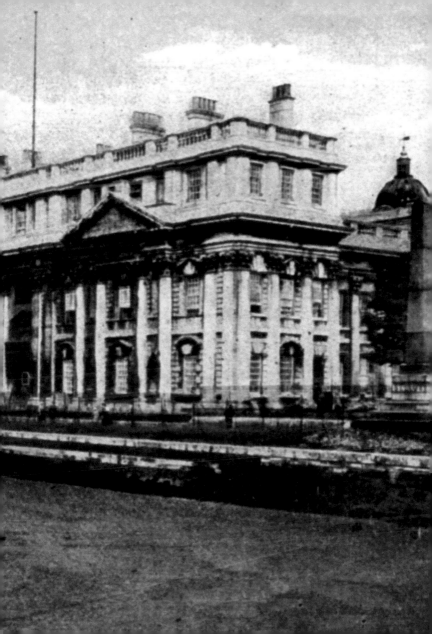

21. THE SHIP TAVERN

The Ship Tavern was an imposing building and the fourth of a succession of inns which had stood on the site since the early seventeenth century. During an air raid in 1941, the tavern and the surrounding houses were severely damaged. The tavern was demolished and the whole area underwent redevelopment at the end of hostilities. During seasonal festivities and summer weekends, international food stalls are set next to where the tavern once stood.

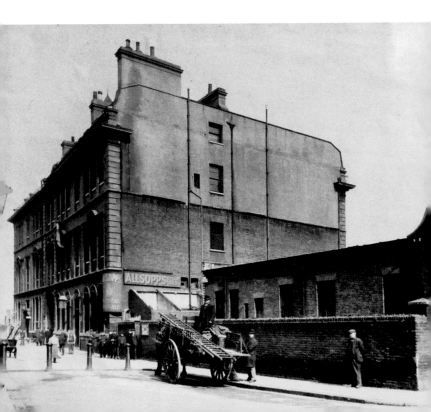

22. *CUTTY SARK*

Built and launched at Dumbarton in 1869, the *Cutty Sark* is the only existing clipper ship to have sailed the tea and wool trade routes around the globe. Placed in dry dock during 1954, while undergoing restoration the ship caught fire in 2007. However, as most of the ship's superstructure, masts and decking had been removed for storage, the damage was not as bad as first feared. On completion in April 2012, the *Cutty Sark* was opened to the public once more.

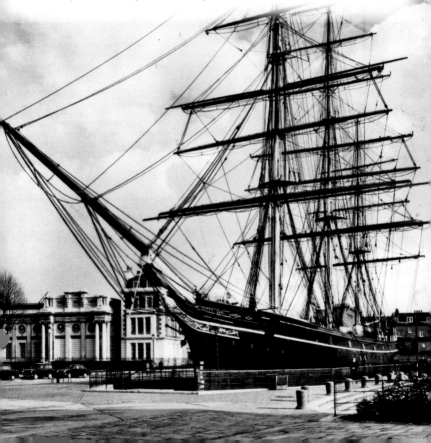

23. GREENWICH FOOT TUNNEL

To the front of the Ship Tavern site, a flight of steps led down to a passenger ferry running from Greenwich to the Isle of Dogs. These ferries had been in operation since the early 1300s but eventually closed after the Greenwich Foot Tunnel, designed by Sir Alexander Binnie, opened in 1902. The tunnel, 375 meters long, is accessed by a lift and spiral staircase, housed under large glass-domed, red-brick, circular buildings, one each side of the river.

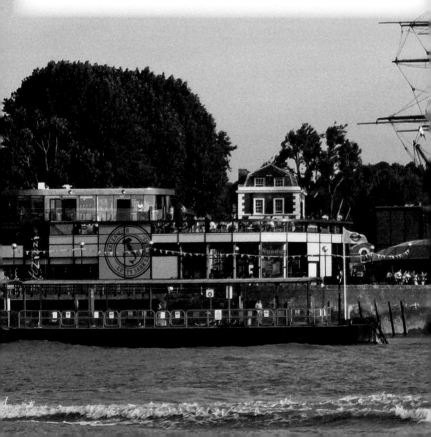

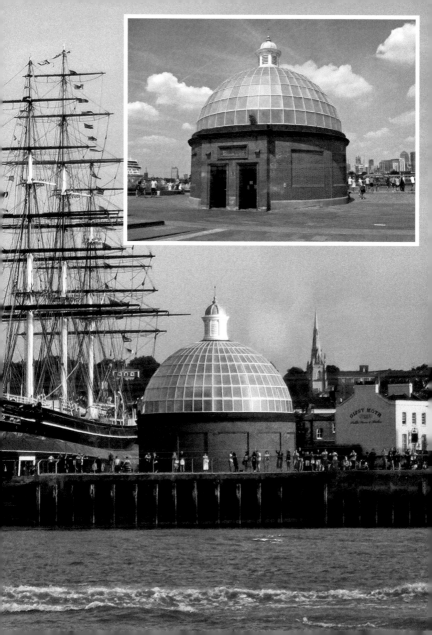

24. MEDIEVAL GREENWICH

The historic medieval centre of Greenwich covered an area from the river to Stockwell Street, a medieval route into Greenwich from Blackheath. A warren of narrow streets and alleyways made up from timber-constructed buildings erected between the fourth and fifteenth centuries, the properties needed constant repair and alteration, which resulted in the centre of Greenwich becoming a jumble of hovels and squalid dwellings.

25. CHURCH STREET

In 1830, Greenwich Hospital Clerk of Works and architect Joseph Kay was tasked in redeveloping the whole town centre. All the medieval buildings were torn down, including where some of the poorest Greenwich residents had lived, with few of the original medieval street lines retained, and a central block of Georgian properties were erected surrounding the market square, incorporating Nelson Street, King William Street, Clarence Street (now College Approach) and Church Street.

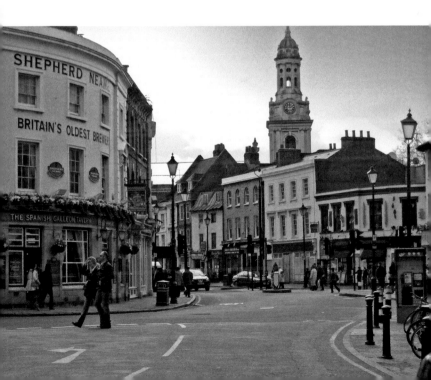

26. COLLEGE APPROACH

By the mid-1900s, many of the Georgian properties needed a high level of repair, several having suffered damage due to bombing during the Second World War, including a row of Georgian properties on College Approach. After repair and renovation throughout the preceding years, Greenwich town centre properties have become much sought after, commanding high rental charges.

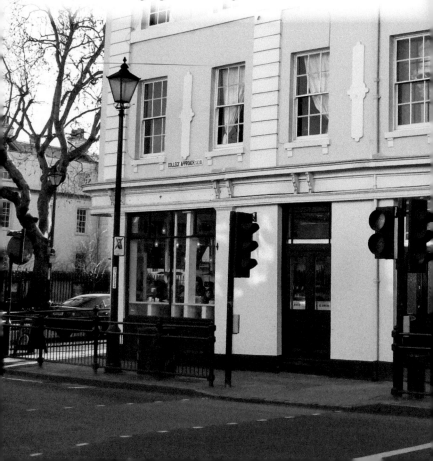

27. ROYAL NAVAL COLLEGE WEST GATE

Dating from 1752, the Royal Naval College West Gate, a stone- and brick-built entrance and porters' lodges, were moved from their original position within the Royal Hospital grounds and erected on the site of the old Greenwich Market during the mid-1800s. The pillars support large stone globes, one celestial one terrestrial, each one measuring 6 feet in diameter and weighing 7 tons.

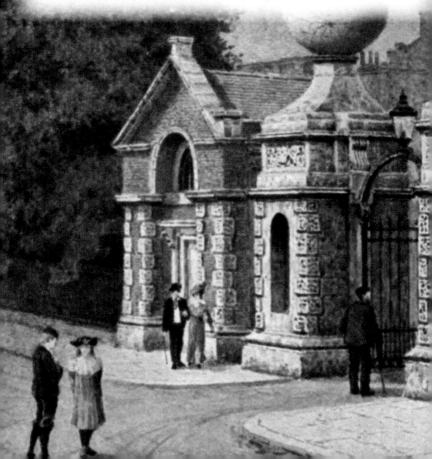

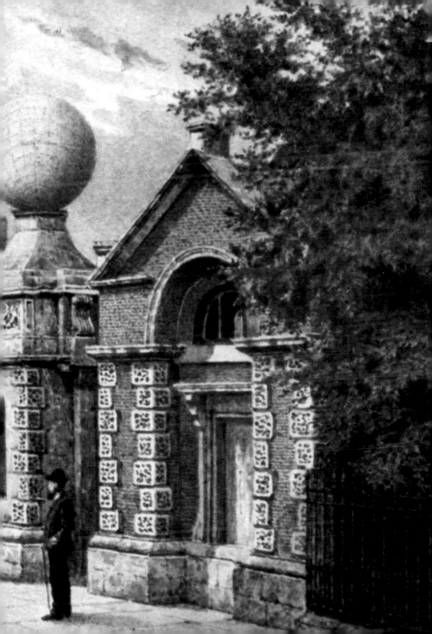

28. DREADNAUGHT HOSPITAL

The Dreadnaught Hospital was named after a succession of man-of-war hulks moored at Greenwich Reach, utilised as hospital ships for the care of sick and injured seamen during the nineteenth century. By 1872, the patients had been moved onshore to the vacated infirmary of the Royal Hospital. The Dreadnought Seaman's Hospital became a specialist unit of the National Health Service until its closure in 1986, the Regency building standing empty for over ten years before conversion for use by the University of Greenwich.

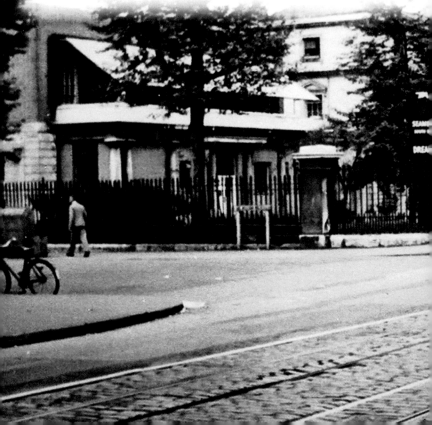

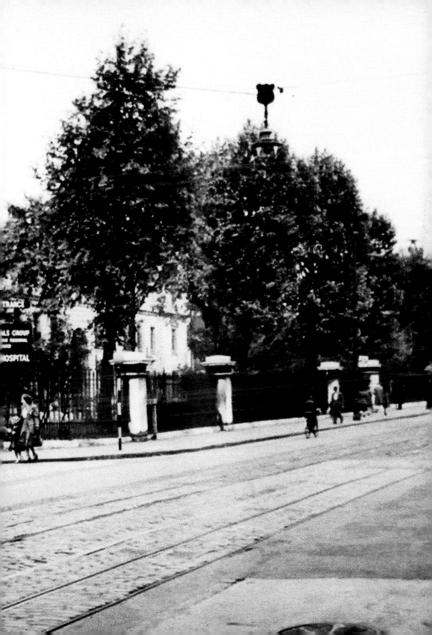

29. ROYAL HOSPITAL SCHOOL

This image shows the Royal Hospital School main gates on Romney Road during the early 1900s, where over 10,000 boys were educated between 1874 and 1930. Taught the art of seamanship, most boys either joined the Royal Marines or Royal Navy, five becoming admirals. When girls were admitted to the school they were educated for a career in domestic service. The National Maritime Museum took over the building to display naval artefacts stored at the Royal Naval College, opening its doors to the public 1937. Central to the museum is the Queen's House, commissioned by Anne of Denmark in 1616 and designed by the Surveyor of the King's Works, Inigo Jones.

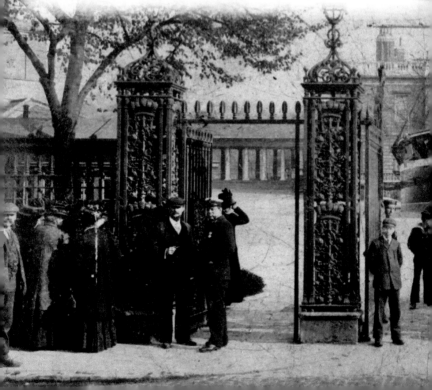

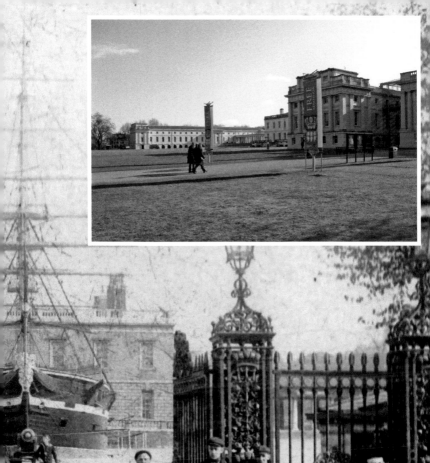
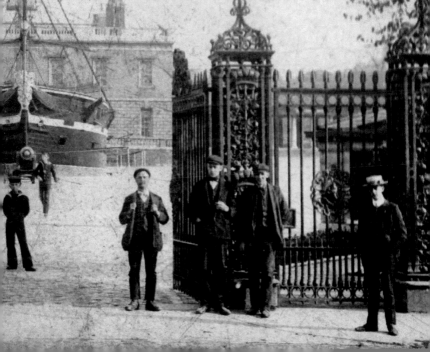

30. NELSON ROAD

Built as part of a new town development by Greenwich Hospital Estates in 1829, Nelson Road was named after the hero of the Battle of Trafalgar, Lord Horatio Nelson. During the 1800s the parade of elegant shops positioned each side of the road running through the middle of Greenwich to the parish church of St Alfege was the most fashionable place to shop in south London.

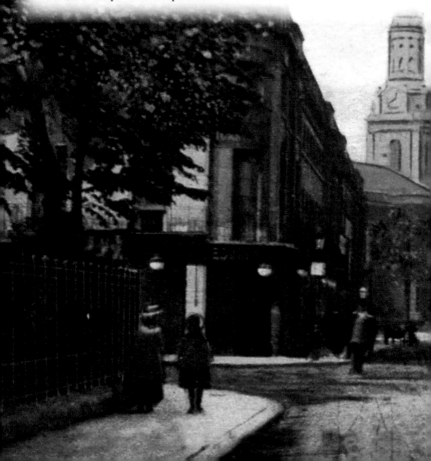

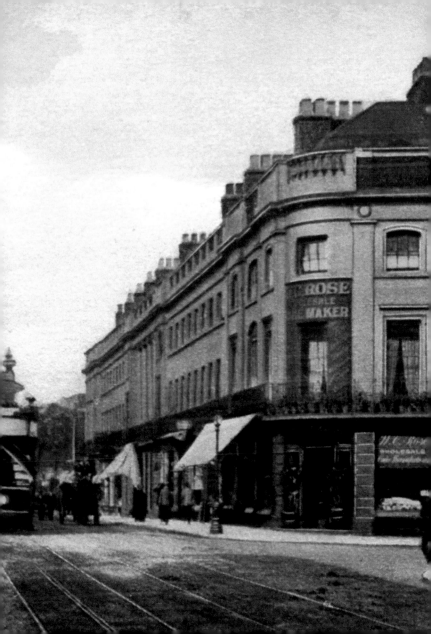

31. GREENWICH MARKET

Greenwich Market transferred from the old naval hospital grounds in 1831, the entrance at Durnford Street, off Church Street, erected as part of the area's redevelopment plan. Awarded a royal charter in 1849, the market included stores, a slaughterhouse, public houses, stables and music hall. Although refurbished in 1958, traditional market trading declined and visitors will now find the market full of arts and craft stalls, boutique shops, galleries, restaurants, eateries and wine bars.

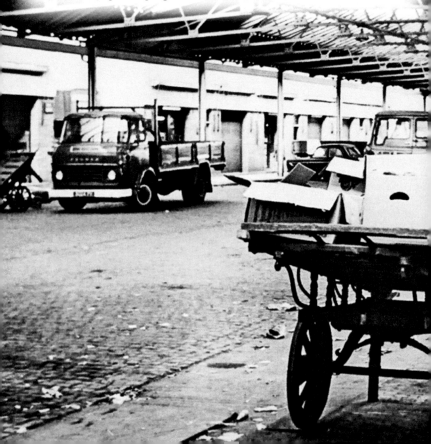

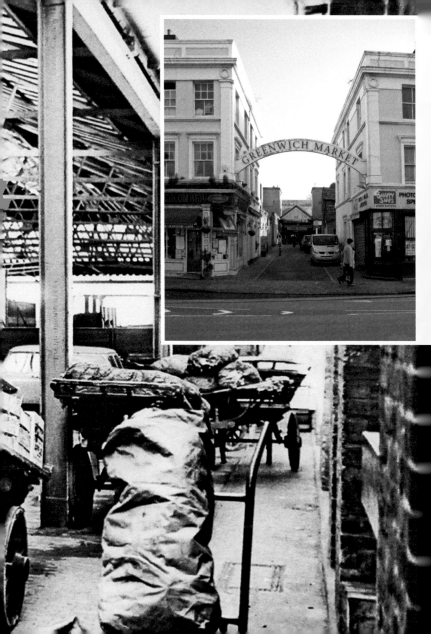

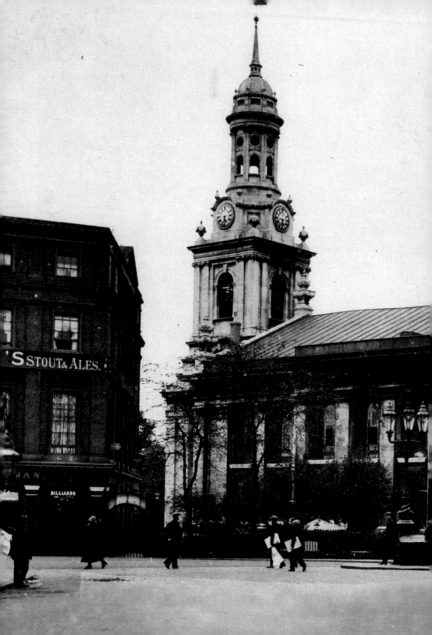

32. ST ALFEGE CHURCH

St Alfege Church is the third place of worship commemorating Saxon Archbishop of Canterbury Alfege, stoned to death by Danish captors in 1012 after failure to secure a ransom demanded for his release. An eleventh-century church erected on the spot where the bishop died was replaced in the thirteenth century by a larger structure which collapsed during a great storm in 1710. Nicholas Hawksmoor designed the current eighteenth-century parish church, retaining and refurbishing the medieval tower which survived.

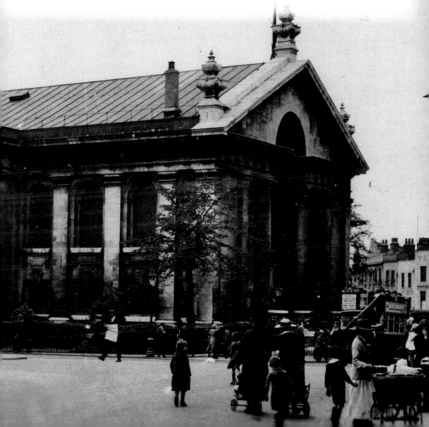

33. DEPTFORD CREEK

The River Ravensbourne is one of few navigational creeks on the Thames. Rivercraft, ships and coastal craft, like the vessel shown at Deptford Creek during the 1950s, required the road bridge over the creek to open, allowing passage through. Industries on the river once included a tide mill, flour mill, shipbuilders, breweries, chemical works and power station. All have now gone, as both sides of the river undergo large-scale redevelopment. *Inset*: Plaque on the side of Deptford Creek Bridge control tower.

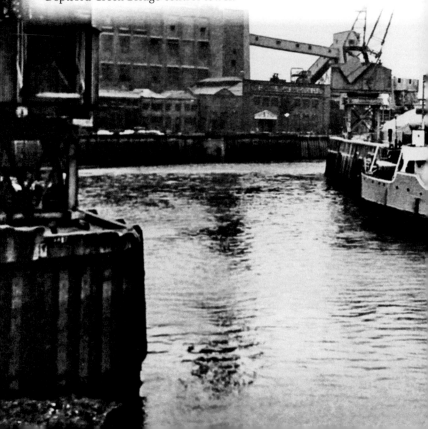

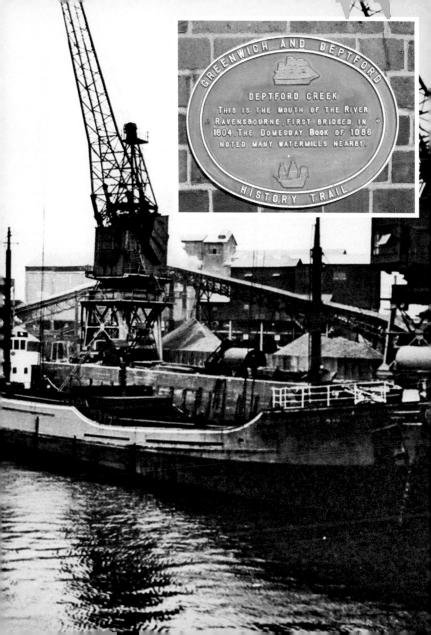

GREENWICH AND DEPTFORD

DEPTFORD CREEK
THIS IS THE MOUTH OF THE RIVER
RAVENSBOURNE, FIRST BRIDGED IN
1804. THE DOMESDAY BOOK OF 1086
NOTED MANY WATERMILLS NEARBY.

HISTORY TRAIL

34. GREENWICH TOWN HALL

The building situated to the right of Greenwich Road was officially opened in 1877 as the District Board of Works Offices. When the Borough Council was formed in 1900, the building became the Council Town Hall. A V1 flying bomb landing on a row of houses next to the town hall during the Second World War caused extensive damage to the roof. When repairs were carried out after the war (minus reconstruction of the dome), in 1958 the building was renamed West Greenwich House, and is now Greenwich West Community & Arts Centre.

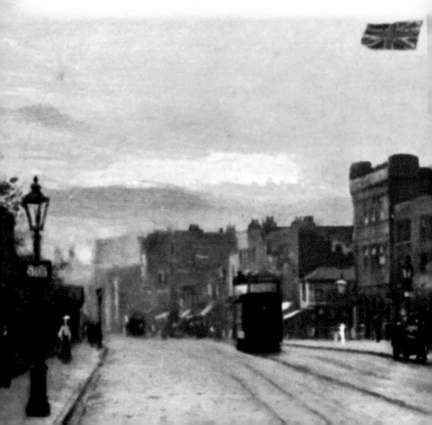

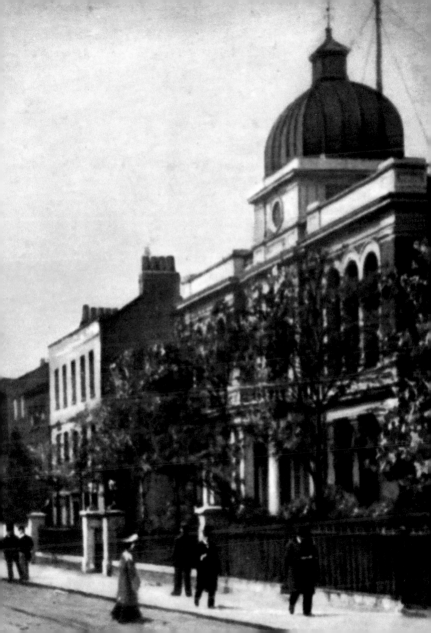

35. LOVIBONDS

West County brewers Lovibonds moved to Greenwich in 1847, building a brewery on Greenwich High Road in 1865. The brewery was damaged by a doodlebug in 1944, which stopped the production of beer for a short period. Although Lovibonds opened branches and depots throughout London, the brewery closed when the brewers were bought out in 1968. John Davy & Co., vintners, founded in 1870, purchased the buildings for use as their main office, wine vault and wine bar.

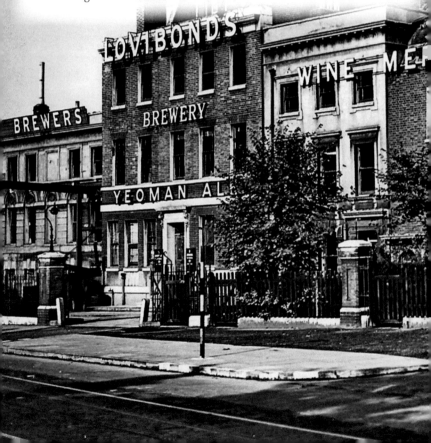

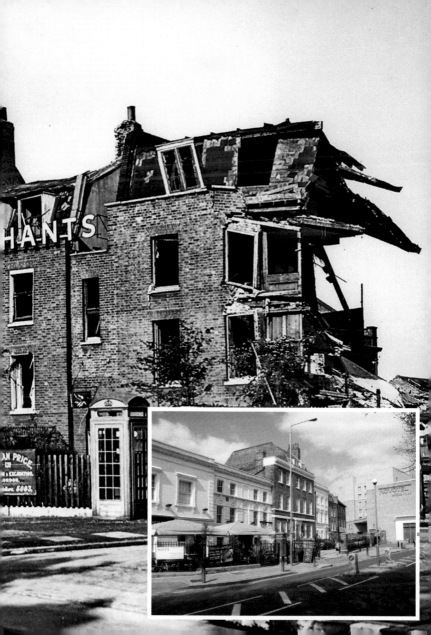

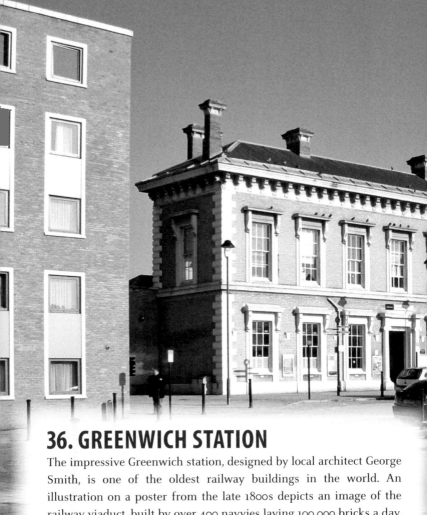

36. GREENWICH STATION

The impressive Greenwich station, designed by local architect George Smith, is one of the oldest railway buildings in the world. An illustration on a poster from the late 1800s depicts an image of the railway viaduct, built by over 400 navvies laying 100,000 bricks a day, causing a national brick shortage. In 1833, the Greenwich to London Bridge railway line was the first passenger service to open in London, and within ten years was carrying 2 million people a year.

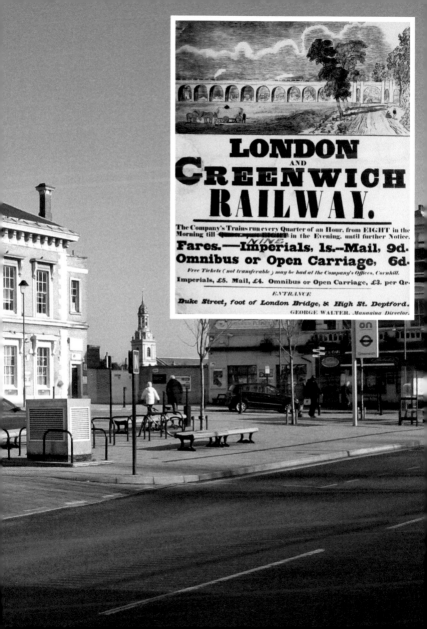

LONDON
AND
GREENWICH
RAILWAY.

The Company's Trains run every Quarter of an Hour, from EIGHT in the Morning till NINE in the Evening, until further Notice.

Fares.—Imperials, 1s.—Mail, 9d.
Omnibus or Open Carriage, 6d.

Free Tickets (not transferable) may be had at the Company's Offices, Cornhill.

Imperials, £5. Mail, £4. Omnibus or Open Carriage, £3. per Qr.

ENTRANCE
Duke Street, foot of London Bridge, & High St. Deptford.
GEORGE WALTER, Managing Director.

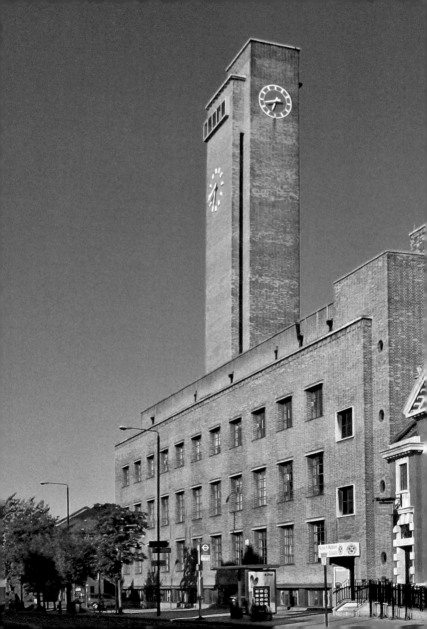

37. BOROUGH HALL

Designed by architect Clifford Culpin, the Grade II art deco-style Borough Hall, erected in 1939 on the corner of Greenwich High Road and Royal Hill, was inspired by Dutch architect W. M. Dudok's Hilversum Town Hall, considered one of the most influential structures of the time. The observation platform at the top of the clock tower, once open to the public, gave spectacular views over Greenwich and beyond. When Town Hall duties were transferred to Woolwich in 1965, the building was converted into office space and the municipal halls used as a performing arts venue.

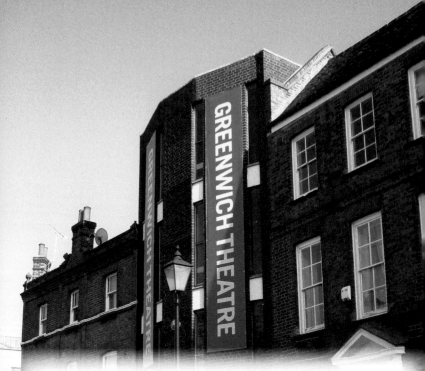

38. GREENWICH THEATRE

During the early days of theatre many popular artists performed at Greenwich, including Ellen Terry, Arthur Lloyd, Kitty Fairdale and Dan Leno. The Carlton Theatre, built in 1864, one of several Greenwich theatres, was renamed Morton's and by 1937 had been converted into a cinema prior to its demolition to make way for the New Greenwich Town Hall. Another theatre, known as the Hippodrome, adjacent to the Rose and Crown public house and music hall, had also been turned into a cinema and faced demolition following damage during the Second World War. Saved after a successful local campaign, the renovated Greenwich Theatre reopened in 1969.

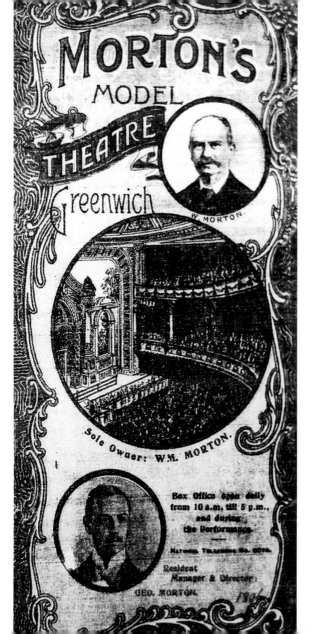

MORTON'S
MODEL
THEATRE
Greenwich

W. MORTON.

Sole Owner: WM. MORTON.

Box Office open daily
from 10 a.m. till 5 p.m.,
and during
the Performance.

NATIONAL TELEPHONE No. 607a.

Resident
Manager & Director:
GEO. MORTON.

39. FLAMSTEED HOUSE

Each day, the red ball atop of a tower at Flamsteed House, designed by Sir Christopher Wren, rises up a mast, then drops at exactly 1300 hours, a signal once used to set marine timepieces of vessels on the Thames. Named after the first Astronomer Royal, John Flamsteed, the observatory was commissioned by Charles II, who donated £500 towards the construction costs. Materials used included reclaimed material from a Tower of London gatehouse and unused bricks from Tilbury Fort.

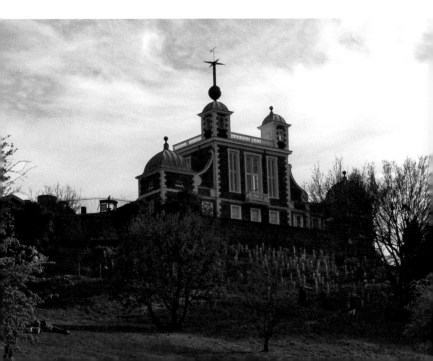

40. GREENWICH MEAN TIME

George Airy, Astronomer Royal from 1835 to 1881, proposed that standard time should be used throughout the world, measured and provided by the Greenwich Royal Observatory. A twenty-four-hour clock showing Greenwich Mean Time, built by Charles Shepherd, was installed in the outer gate wall of the observatory in 1852. One of the earliest examples of an electric timepiece is worked through a slave mechanism controlled by electric pulses transmitted from within the observatory.

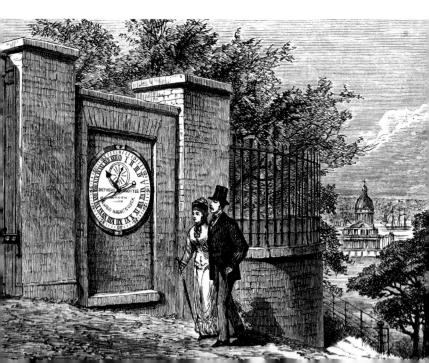

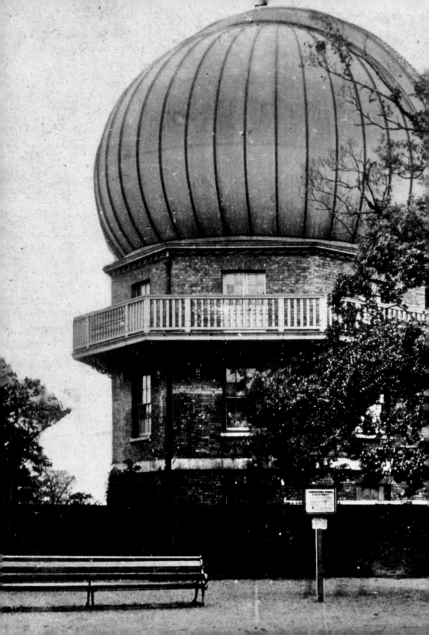

41. GREENWICH OBSERVATORY

Erected on the site of the disused Greenwich Castle, Greenwich Royal Observatory's function, on completion in 1676, was to develop and establish accurate astronomical navigation at sea. In 1884, at the International Meridian Conference held in Washington DC, a delegation voted Greenwich the Prime Meridian, from where all time zones were set and measured. Dividing the globe east and west, the line of longitude (0 degrees) was marked by a brass strip, the Meridian Line, running across the observatory forecourt, down a boundary wall, and over a pedestrian pathway.

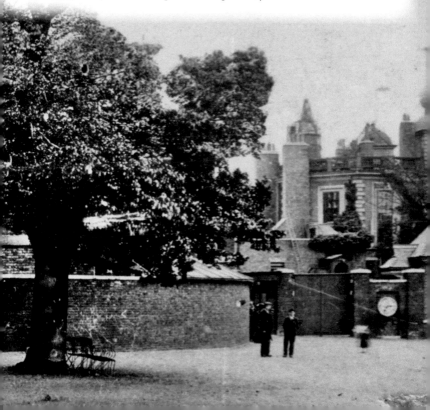

42. PETER HARRISON PLANETARIUM

The ultra-modern, 120-seat Peter Harrison Planetarium, which opened in May 2007, is housed below a 55-ton, bronze-built cone, which, at the time of opening, was the only operating planetarium in London. Named after the foundation providing funding to build the centrepiece of the Royal Observatory's 'Time and Space' project, the digital laser theatre, accessed by the Weller Astronomy Galleries, presents themed, state-of-the-art celestial sound and light shows.

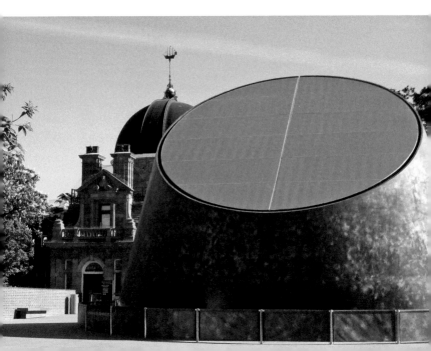

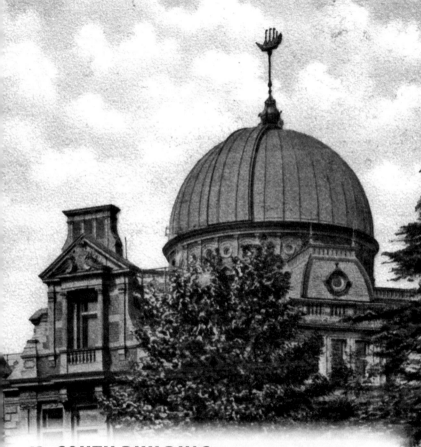

43. SOUTH BUILDING

Built between 1891 and 1899, the South Building at the Royal Observatory, used for the study of astronomical photography, housed two Thompson Equatorial telescopes. When the observatory relocated to Herstmonceaux in 1957, the Greenwich Royal Observatory turned towards tourism, opening as a museum of astronomy, navigation and timekeeping.

44. RANGER'S HOUSE

To the western edge of Greenwich Park is the Ranger's House, originally a small property rebuilt by seafarer Admiral Francis Hosier during the early 1700s. Inherited by the 4th Earl of Chesterfield, who named the villa Chesterfield House, various alterations and additions were carried out before acquisition in 1782 by Edward Hulse, High Sheriff of Kent and Deputy Governor of the Hudson's Bay Company. The house became a Grace and Favour residence for members of the royal household, and later the official residence of the ranger of Greenwich Park. Now in the care of English Heritage, the Ranger's House is home to the Wernher Collection – works of art, silver, jewels, bronzes and porcelain assembled by German-born diamond mine entrepreneur Sir Julius Wernher.

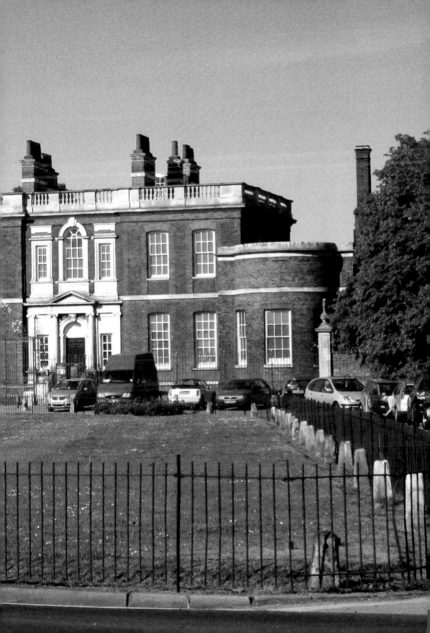

45. BLACKHEATH FOLLY POND

During the late 1800s, Greenwich residents could go boating on Folly Pond, or Long Pond as it was also known, opposite Greenwich Park's Blackheath gates. The pond's origin was a gravel pit, filled with water for use in watering cattle travelling the Dover Road. The pond is no longer used for boating and the water source is supplied through a standpipe installed to stop the pond from drying out during the summer.

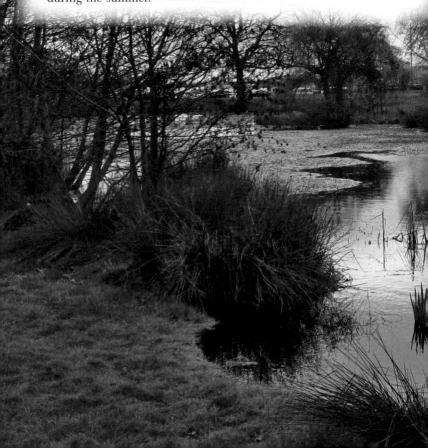

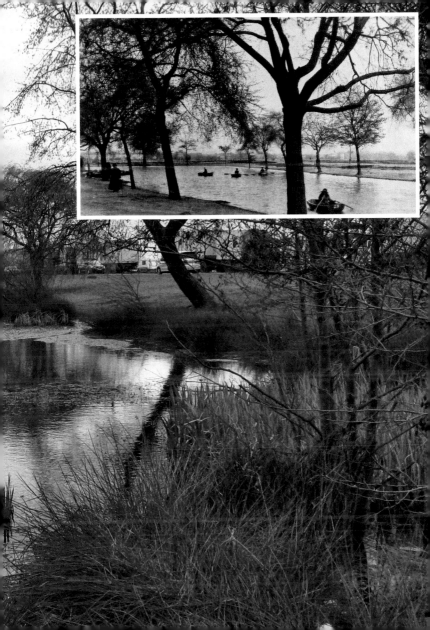

46. GATE LODGE

The keeper of the park's lodge was built in 1852 to the designs of architect John Phipps. The mock Tudor-style lodge replaced a seventeenth-century keeper's lodge located at the park's centre. Also used as a residence for the park's deer keeper, the lodge eventually fell into disuse. Refurbished during the early 2000s, the three-bedroom lodge, which has private parking and access to the park, is available for private rental.

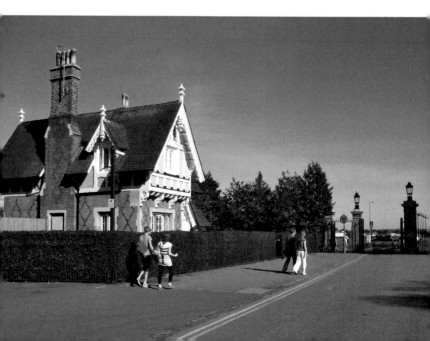

47. GREENWICH PARK DEER

Although Edward III hunted wild deer in the manor of Greenwich during the fourteenth century, Henry VIII was first to introduce deer into the enclosed Greenwich Park specifically for hunting while holding court at Greenwich Palace in the early 1500s. The herds roamed freely until 1927, when they were held in enclosures at weekends due to the rise in visitor numbers to the park, many deer falling ill and dying after being fed the wrong type of food. The red deer and fallow deer herds were eventually moved to a permanent enclosure in the Wilderness, at the park's south-east corner.

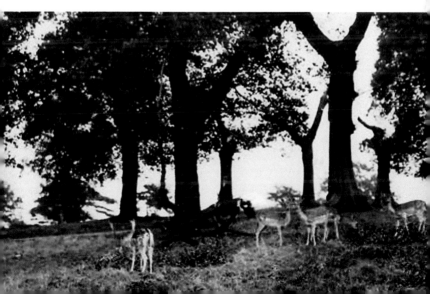

48. QUEEN ELIZABETH'S OAK

Towards the park's centre, a tall tree, dating to the twelfth century and known as Queen Elizabeth's Oak, was held up by twisted branches of ivy after dying during the nineteenth century. According to legend, Henry VIII and Anne Boleyn danced around its trunk, and Elizabeth I took refreshment under the shade of its leafy green canopy when out riding from Greenwich Palace. The ancient tree came down during a torrential rainstorm in 1991, the remains left where they fell, and a new oak sapling was planted close by.

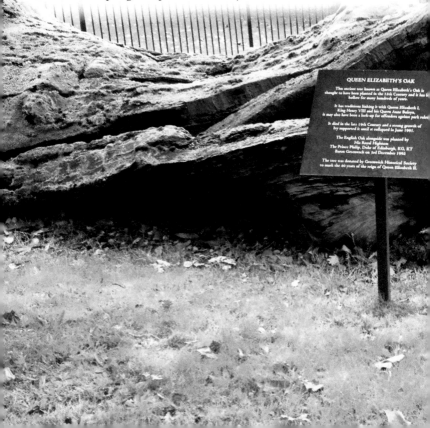

49. MOTHERSTONE FOUNTAIN

Towards the centre of Greenwich Park, at the end of Lovers Walk,
there is what appears to be a prehistoric monument. Although
the stone fountain is not as ancient as it looks, erected during the
mid-1800s, the stones used in its construction, Preseli bluestone,
are the same as those forming the inner circle of Stonehenge. The
fountain was known by pagan worshipers as the Motherstone, or
Goddess Stone. The water once fed through lead pipes originating
from a natural spring.

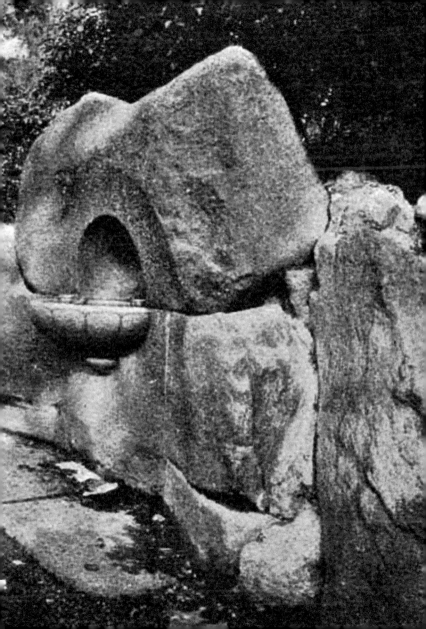

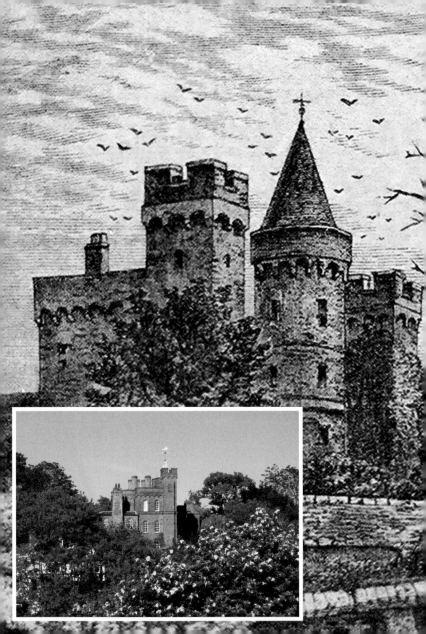

50. VANBRUGH CASTLE

Opposite Maze Hill Gate, to the east of Greenwich Park, is the mock castle built by architect and dramatist Sir John Vanbrugh in 1717. Vanbrugh Castle was said to have been modelled on the French Bastille, where Vanbrugh had been imprisoned in 1690, accused of being a British spy. The castle remained a private residence until serving as a school for the children of RAF personnel during the mid-1900s. Afterwards it returned to private ownership and the castle was converted into exclusive residential apartments.

51. GREENWICH PARK CONDUIT

Below the surface of Greenwich Park are a series of brick tunnels believed to have been built during Tudor times. Carrying water down to a cistern for supplying water to Greenwich Palace and later the Royal Hospital, pensioners using the water for washing their clothes and brewing beer in the hospital brewery – beer was much safer to drink than the water. The large brick-built conduit entrance, at the foot of One Tree Hill, once gave access to these mysterious tunnels. The now bricked-up tunnel entrance was once rumoured to lead all the way to the Neolithic caves at Chislehurst in Kent.

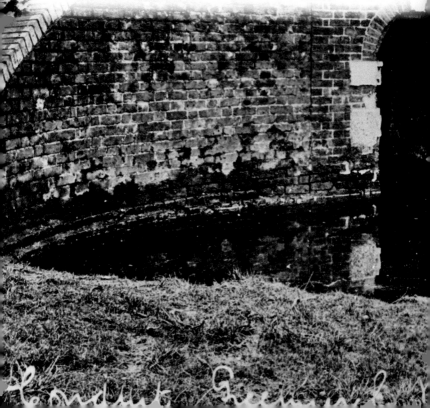

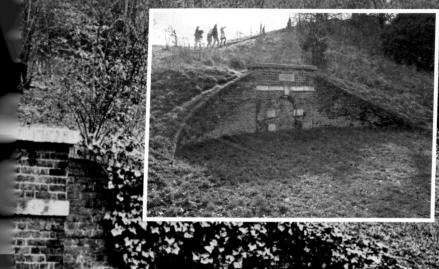

ACKNOWLEDGMENTS

I should like to thank all those who have contributed to *Greenwich History Tour*, either by supplying images or memories which I have been able to use within the pages of this publication. Many of the period photographs have come from my own collection, gathered together over many years and obtained from family members and friends, local history libraries, postcard fairs and antiquarian shops. The recent images were taken during my return trips to Greenwich over the previous year. I should also like to thank all those who have provided specific historical information or have given permission to use their images within the publication. If for any reason I have not accredited any images to people or organisations as necessary, or failed to trace any copyright holders, then I should like to apologise for any oversight and will make the necessary changes at reprint.

I should also like to express my thanks to the following list of organisations and people without whose help I would not have been able to produce this book: the Local History Library at the Greenwich Heritage Centre, the Greenwich Industrial Heritage Society, the National Maritime Museum, Royal Parks, the Cutty Sark Trust, Greenwich Foundation for the Old Naval College, Ray Gallagher, Andrew Lovibond, Jeff Rosenmeier – Lovibonds Brewery Ltd, Bob Headley, family members and friends.